WHEREVER
YOU ARE,
WHATEVER
YOU DO,
WHOEVER
YOU COME
FROM—
YOUR STORY
MATTERS.

SO GOD MADE

_____ 'S

STORY

WRITTEN WITH LOVE BY

DEDICATED TO

DATE

SO GOD MADE A
mother's story

✦

a keepsake journal

✦

CREATED BY
LESLIE MEANS
FOUNDER OF *HER VIEW FROM HOME*

TYNDALE
MOMENTUM®

A Tyndale nonfiction imprint

Visit Tyndale online at tyndale.com.

Visit Tyndale Momentum online at tyndalemomentum.com.

Visit the author at herviewfromhome.com.

Tyndale, Tyndale's quill logo, *Tyndale Momentum*, and the Tyndale Momentum logo are registered trademarks of Tyndale House Ministries. Tyndale Momentum is a nonfiction imprint of Tyndale House Publishers, Carol Stream, Illinois.

So God Made a Mother's Story: A Keepsake Journal

So God Made a Mother is a registered trademark of *Her View From Home*, LLC

Designed by Dean H. Renninger

Published in association with Folio Literary Management, LLC, 630 9th Avenue, Suite 1101, New York, NY 10036.

For information about special discounts for bulk purchases, please contact Tyndale House Publishers at csresponse@tyndale.com, or call 1-855-277-9400.

ISBN 978-1-4964-9064-3

Printed in China

30	29	28	27	26	25	24
7	6	5	4	3	2	1

Contents

Introduction

MOM WROTE ME A LETTER when I was in college. An excellent typist, she composed most of it from her computer. Inside her note, she left pieces of advice and words of wisdom. And at the end, she signed it in cursive, with ink:

I love you, Mom.

I cherish that letter. I love the advice inside, and her penmanship is truly lovely—but the thing I love most about that note is the way she ended it.

I love you.

Mom didn't often speak or write those words. Maybe it's a generational thing, a product of being born in the late 1940s. Tough love and all that jazz.

For whatever reason, "I love you" is much easier for me to say out loud.

I say it at the end of phone calls and when we talk, and I write it for the world to read.

"I love you, Mom!"

It's how I tell my loved ones how I feel.

But Mom? She showed me.

In a batch of freshly baked cookies.

As she twirled my hair when I sat on the edge of her bed.

In the silence when we rocked together on our front-porch swing.

In her cheers when she sat in the stands of my childhood sporting events.

In her hug on the day I married the love of my life.

In the hospital room when she held my first baby girl.

Mom shows her love in action because sometimes it's just too hard to write it down. It's hard to tell the world how you feel.

But just as I cherish that note Mom wrote me all those years ago, the people you love crave your words, your inmost thoughts, your story.

This journal will guide you through sharing precisely that.

Why does it matter? Because, friend, your story matters. Your family loves you dearly and wants to know what makes you *you*. What were you like as a child? What makes you happy? What makes you mad? What makes you want to skip and dance and shout for joy? They want to know about your first love, your wedding dress, your hopes, your dreams, and your secret fears.

Having those details preserved in your own words, in your own handwriting? It's a gift that will be cherished long after you're gone.

I encourage you to move through these pages at your own pace. Imagine someone you love sitting across from you (probably over a plate of cheese) asking you these questions. Maybe you'll finish the whole thing this weekend. Maybe you'll still be adding to it this time next year. There's no pressure and there are no perfect answers—there's simply this invitation to open your heart and let it spill onto a page.

Sprinkled throughout these pages are quotes from *Her View From Home* writers who contributed to *So God Made a Mother*— the book that inspired this journal. We asked them to share the wit and wisdom of their own mothers and grandmothers, and they definitely delivered.

Now it's your turn. Once you breathe life into this book, it will become an everlasting *I love you* . . . whether you say the words or not.

The world needs your story—it's time to share it.

xo, Leslie

Section 1

Tender Beginnings

✕

Mama always said mothering is hard—if I made it look easy, it was only because you were easy to love.

KIRSTYN WEGNER

When and where were you born?

What is the meaning behind your name?

What do you know about the day you were born
or early days with your parents?

Tell me about your family.

Siblings

Parents

Grandparents

My granny always said, "Ice cream for a tummy ache
and hot chocolate for a sore throat."
KRISTA WARD

What is your earliest memory?

Mama, did it hurt
when I was born?

It can be painful.

So it can hurt
to be a mom?

Sweetheart,
you have no idea.

ELIZABETH ALLISON

What did your parents do for a living?

Describe a typical day in your childhood.

Did you have a nighttime routine?

Were there certain prayers you said?

Did you have favorite books at bedtime?

Describe the home you grew up in.

What did it sound like?

What did it smell like?

What was your bedroom like?

What was the kitchen like?

Where was your favorite hiding place in your house?

If you don't see
God's goodness,
then it's just around
the corner for you.

CHELSEA OHLEMILLER

What do you remember most about your parents?

What do you remember most about your grandparents?

What do you remember about your grandparents' homes?

What did you dream about becoming when you grew up?

Did you keep a diary or journal? If so, do you still have it?
What did you write about?

Where did you go to elementary school?

Who were your best friends as a child?

Whenever I was really in the middle of something hard,
Mom would tell me, "Spring always comes."
REBECCA COOPER

Describe your most memorable birthday.

Who was your first crush?

What were family dinners like at your house?

What was your favorite meal?

Share the recipe for a favorite childhood meal.

Did you have a favorite pet as a child?

What was your favorite way to spend your free time?

I liked to eat butter when
I was a kid. Just butter.
My mom would say,
"Eat all you can now,
because someday you
may not think that's
such a good idea."

JEN THOMPSON

Did you prefer to play inside or outside? Why?

Did you have a favorite board game?

What is the biggest news story or event you remember
from your childhood?

What is the first book you remember reading?

What were your chores around the house?

What was the most memorable vacation your family took?

**Children remember the simplest times: blanket forts,
finding the Big Dipper, rug picnics, running in the rain.**
LISA LESHAW

Share a funny story from your childhood.

Share a sad memory from your childhood.

Was there anything you were afraid of?

Is there a scent or sound that takes you back to your childhood?

What was the best gift you received as a child?

When you think back on your childhood,
what stands out most in your memory?

Growing Strong

✕

Just because you start down a path doesn't
mean you can't stop and turn around.
It's never too late to change direction.

GINGER HUGHES

Describe a time you got into trouble or learned a tough lesson.

Describe your first date.

What do you remember about your first kiss?

Describe the first time you fell in love.

Describe your first car, including how much it cost.

What was your first job? How much did you earn per hour?

It's okay if you don't like me right now—
I'm not your friend, I'm your mother.
EMILY SOLBERG

Who was the most influential teacher you had?

What was your favorite outfit or style of clothing?

What was your favorite dance?

Hungry?
Have a banana.
They're nature's
energy bars!

SARAH LUKE

How did you celebrate your sixteenth birthday?

What extracurricular activities were you involved in?

What were the fads when you were in high school?

Who were the most influential people in your life as a teenager?

The world is at your feet.
Did you know that?
The whole world.

Now stepping out
and loving those in it—
that will be the bravest
thing you ever do.

REBECCA NEVIUS

What were some of the biggest news events when you were a teenager?

Did you or any of your family or friends serve in the military?
Describe what that was like.

What was your favorite book and why?

What was your favorite movie and why?

What was your favorite TV show and why?

What was your favorite song and why?

Where did you go to high school?

What did the high school you attended look like?

> We can't deprive our kids of their struggle—
> it's how they become who they're supposed to be—
> but we can be their soft place to land.
> KATHY RADIGAN

What was the hardest class you took in high school and why?

What was your favorite class in high school and why?

What size was your graduating class?

What was your high school graduation like, and how did you celebrate?

Tomorrow will be a new day to try again.
AMY JUETT

What did you want to do after high school? Did you do it?

Who was the first presidential candidate you voted for?

Would you vote the same way today?

Where did you live when you moved out of your childhood home?

> The best advice my mom ever gave me was
> to show up. She never spoke those words,
> but she was there—for everything.
> KELSEY SCISM

What was challenging about living on your own?

Did you go to college?

How did you decide what to major in at college?

If you had roommates, what were they like?

What surprised you about living on your own for the first time?

How did you celebrate your 21st birthday?

What was the hardest decision you made as a young adult?

What did you believe about God as a young adult?

How would you describe your faith?

Don't walk
between
parked cars.

AMBER WATSON

How did you motivate yourself to keep going on hard days?

What event or holiday did you most look forward to each year?

Who were your best friends, and what were they like?
Are you still friends today?

What do you remember most about your teenage and early adult years?

Section 3

Something Beautiful

On your worst days, put on your best outfit.

KIERRA TATE HENDERSON

How did you meet your spouse?

What attracted you to each other?

How long did you date before getting married?

What was the most memorable date you went on together?

Describe how you got engaged.

How did you know your partner was the one?

Mama always said
your body is the least
interesting part of you;
it's that gorgeous soul
that shines through.
No one dwells on the
looks of a firefly but on
its captivating light that
contrasts the night sky.

CELESTE YVONNE

What kind of wedding did you dream of having—and did you have it?

Describe your wedding day.

What did you do before the ceremony?

What was your wedding dress like?

What music was included?

Who was in your wedding party?

How much did your wedding cost?

What readings were included in your wedding ceremony?

Describe your wedding reception.

Where was your wedding reception?

What food was served?

What were the decorations like?

What was your cake like?

What was the music like?

What do you remember about the wedding toasts?

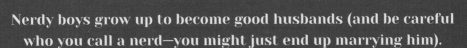

Nerdy boys grow up to become good husbands (and be careful who you call a nerd—you might just end up marrying him).
JENNY ALBERS

How much did the reception cost?

How did you make your exit?

Where did you go on your honeymoon?

What was the most romantic moment as a newlywed?

What was the most humorous moment as a newlywed?

Which side of the bed do you sleep on?

**If you need a more cheerful point of view,
try washing your windows.**
KIT TOSELLO

Describe a place you liked to visit together.

What was the first meal you cooked together?

Share a recipe for something you ate often.

Describe your first home.

Where was it?

What was the layout?

How much did you buy or rent it for?

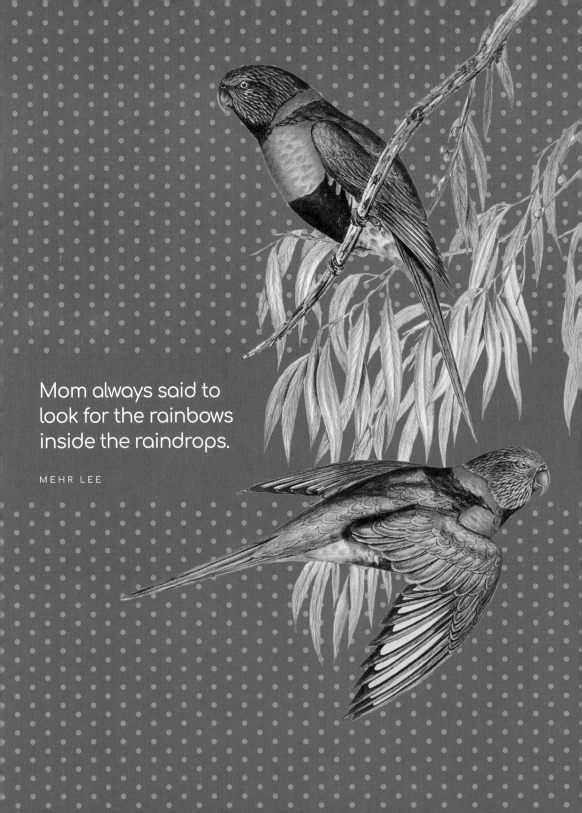

Mom always said to
look for the rainbows
inside the raindrops.

MEHR LEE

How did you decorate it?

Did your home have any quirks?

What was the first big purchase you made with your spouse?

What did you like to do together for fun?

Where did you work before you had kids?

How did you spend your first Christmas together?

> ### Fish and relatives start to smell after three days.
> CAROLYN MOORE

What was your most memorable time together before you had kids?

How did you spend your first anniversary?

What's something surprising you learned about each other
in the first year of marriage?

How did you feel when you found out you were going to be a mother?

How did you know you were pregnant?

How did you share the news with your spouse?

Who, other than your spouse, did you tell first?

How did you decorate the nursery?

What excited you most about becoming a mother?

What scared you the most about becoming a mother?

Did you have a baby shower?

What was the most sentimental gift you received for your new baby?

Is there anything you splurged on before your first baby arrived?

Did you have any special hand-me-downs for your baby?

Mom said, "These are not wrinkles,
they are signs of all the joy you brought to my face."
STACEY TADLOCK

What was your first day as a mother like?

What do you remember about your labor and delivery?

Share the story behind the name(s) you chose.

Describe what it felt like to bring your new baby home.

What was nighttime like with your newborn?

What surprised you most about growing your family?

What was one thing you couldn't live without
in the early days of motherhood?

Who did you turn to for advice as a new mom?
What advice did you receive?

How did having a baby change your marriage?

How did becoming a mother change you?

What holiday traditions did you start for your family?

Christmas

Easter

Fourth of July

Thanksgiving

Mom always said,
"Just call me and
we'll hug first,
talk later."

BAILEY KOCH

What was the hardest thing you went through
as a couple in the first five years of marriage?

What were some of the happiest moments
of your first five years of marriage?

What do you remember most
about growing your family?

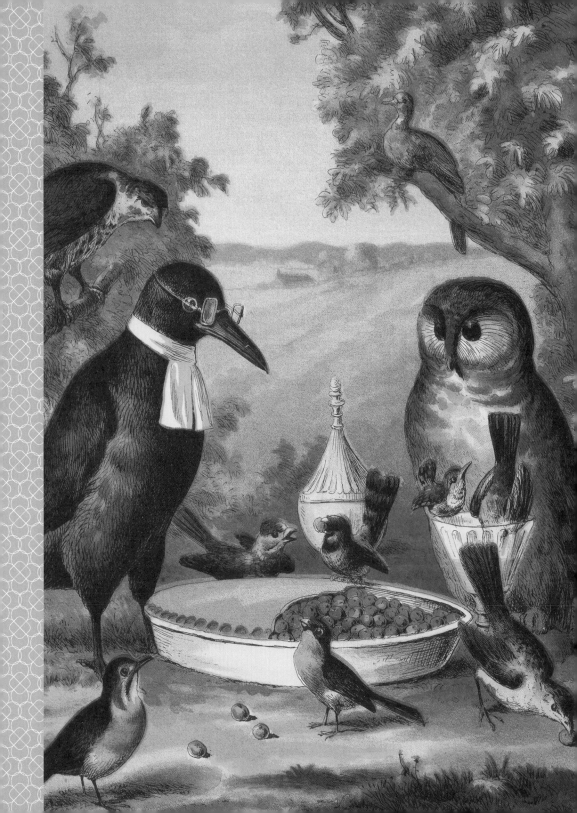

Proud Moments

✕

Mom was proud. Of me, of my siblings, of her grandkids. And the older I get, the more I realize the weight of those five letters snuggled together. We need to know our parents are proud.

MANDE SAITTA

Share three words to describe each of your children.

What did you notice about your kids and their personalities as they grew?

How did you feel about sending your kids to school?

What was it like on the first day of kindergarten?

Nervous as a cat in a room full of rocking chairs.

AMY BETTERS-MIDTVEDT

What was it like on the first day of middle school?

What was it like on the first day of high school?

What was it like on the first day of college?

Mom always said, "I love you."
No matter how embarrassing
it was. No matter where we
were. No matter who else
was there. She always said it.

REBECCA HASTINGS

As a mother, what did you worry about the most?

What brought you the most joy about raising kids?

> **Always wear clean underwear
> in case you get in an accident.**
> TIA HAWKINS

How did you handle disappointment?

What is the best advice you gave your kids?

What is something your children taught you?

Describe a time you felt proud of your children.

What was the first big trip you took as a family?

What was the most memorable mode of transportation
you took on a trip with your family?

Is there a vacation memory that stands out?

One of our main jobs
as moms is for our kids
to feel confident in who
they are, not dependent
on who we are.

ESTHER JOY GOETZ

What is the best compliment you received as a mother?

What did a typical weeknight look like for your family?

What did a typical weekend look like for your family?

What was your go-to meal on busy nights?

Share a recipe for a favorite go-to meal.

How did you feel when your kids started driving?

What time was curfew for your teens?

> **Store your potato chips in the freezer.**
> **They will taste amazing!**
> CAROLE JOHNSTON

What expectations did you set for your kids?

What role did faith have in your family?

Where did you go to church?

What was your most frequent prayer?

What surprised you about having teenagers?

How was life different for your teenagers compared
to what your teen years were like?

What was considered cutting-edge technology?

What were your rules for TV, phones, and technology
when your kids were teenagers?

There's nothing like having your babies under one roof.
LIZZY M. CHRISTIAN

Was there anything that broke your heart when your kids were teenagers?

What did you enjoy most about having older kids?

What challenged you most about having older kids?

How did you react when your kids were hurting?

What kind of self-care did you practice?

Whose advice did you seek out as a mother of teens?
What advice did you receive?

Mothering doesn't stop when our children turn eighteen, move far away, or have their own kids. It just changes.
DANIELLE SHERMAN-LAZAR

Did you make any major renovations to your house?
If so, what were they?

What was your favorite part about where you lived
when your kids were growing up?

What would you change about where you lived
when your kids were growing up?

Did you move houses or cities when your kids were growing up?

What words or phrases did you say most to your teenagers?

What words or phrases did your teens say most to you?

How did you feel when you had to let your kids go?

What is the hardest part of being a mother?

What is the best part of being a mother?

What do you remember most about your kids growing up?

Section 5

Fully Known

✕

You get to be really, really sad (or anxious or scared or proud) if you need to be. Motherhood is exhausting and scary and filled with beautiful, heart-stopping, tear-jerking, breathtaking moments, and we get to feel every emotion.

MIKALA ALBERTSON

What is something you're glad you tried?

Is there anything you regret trying?

What's the most painful thing you've gone through?

The only person I can be is me.

DEBBIE PRATHER

How did you get through it?

Is there a time you felt God calling you to something specific?

If you don't deal with grief,
grief will deal with you.
So take time to heal,
sweet girl, and do it
for you. I love you.

MISSY HILLMER

Is there a time you saw God's plan clearly?

Is there a time you questioned God's plan?

What is your most frequent prayer, said or unsaid?

What Scripture do you turn to most often in your
faith journey and why? Share the verses here.

**Never lock a door so tightly that
it cannot be opened with love.**
KATHY GLOW

What are you most passionate about?

What is your pet peeve?

What is your favorite way to spend a day?

How has that changed from 20 years ago?

What is your relationship like with your extended family?

Do you get together for family reunions?

All you need is a really good friend or two. Find that, and you've hit one of life's greatest jackpots.

ALYSE BRESSNER

Describe any high school or college reunions you've attended.

What technology can't you live without?

Share a piece of writing that is meaningful to you.

What has been the biggest news event of your lifetime?

Describe someone who influenced you greatly.

If you could spend one day with anyone, who would you choose?
What would you do?

What is the greatest loss you've experienced?

What have you learned about yourself as you've encountered grief?

What do you consider your biggest mistake?

What did you learn from it?

What will you miss about today when tomorrow comes?

JILL ROBINSON

What do you consider your greatest success?

What did you learn from it?

Describe your best friend. What do you like to do together?

How have your friendships changed over the years?

What are (or were) your dreams for retirement?

Describe a time you doubted yourself.

Describe a time you were bold.

Describe a time you felt afraid.

What is your love language?

How does it differ from those you're closest with?

What service or volunteer organizations have you been involved in?

What prompted you to serve in that way?

All I want for my
birthday is for you
kids to get along.

AMANDA McCOY

Have you advocated for a cause? Describe the experience.

How have your values grown or changed as you've gotten older?

What makes you cry?

What brings you joy?

What are your favorite things?

Favorite flower:

Favorite food:

Favorite book:

Favorite season:

Favorite movie:

Favorite song:

Favorite scent:

Favorite game:

Favorite Bible verse:

Favorite outfit:

Favorite home:

Favorite place to travel:

Favorite time of day:

Favorite piece of jewelry:

Favorite photo: _____

Favorite haircut: _____

Favorite car: _____

Today's date _____

What is the price of a gallon of milk? _____

What is the price of a gallon of gas? _____

What is the price of a hotel room? _____

What is the price of a new car? _____

What is the price of a single-family home? _____

Who are the biggest celebrities?

What are the most popular TV shows?

What are the bestselling books?

What defines you as a mother and a person in this season of life?

Section 6

Unforgettable

I wish you could stay longer.

JENNIFER BOYD-ROSS

Share your best advice for . . .

Young kids

Teens

College

Dating

Marriage

Raising babies

Where do you want to travel?

Who do you wish you could meet? What would you ask them?

What do you want your funeral to be like?

What do you want on your headstone?

> **What's the worst that could happen?**
> **If they tear you limb from limb, I promise to come back**
> **and collect all your body parts.**
> DEB PRESTON

What people have had the greatest impact on your life?

What family traditions do you hope will continue?

Describe the most romantic moment of your life.

What's the kindest thing someone has ever done for you or said to you?

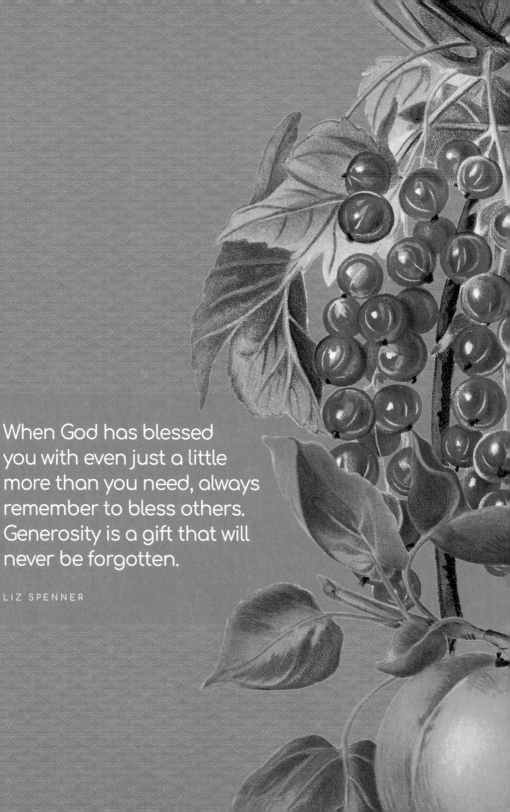

When God has blessed
you with even just a little
more than you need, always
remember to bless others.
Generosity is a gift that will
never be forgotten.

LIZ SPENNER

What is the easiest yes you've ever said?

What is the easiest no you've ever said?

Where do you feel most relaxed?

What makes you feel anxious?

What are your fears about aging?

One good sweep is better than nine bad moppings.
MARALEE BRADLEY

What are you looking forward to most about getting older?

How do you celebrate your birthday?

What is your most cherished possession?

Cuando tengas hijos te acordarás de mí.
(When you have your own children, you will remember me.)
ALIETTE SILVA

Describe how you felt when you turned . . .

21

40

50

65

80

What is the hardest thing you've ever had to do?

If you could, tell what moment you would choose to relive . . .

With your kids

With your spouse

With your parents

With your friends

Describe your hope for your children when it comes to . . .

Love

Career

Happiness

Faith

What have you learned about love?

How has your career impacted you?

Is there any skill or knowledge you'd like to learn?

How are you different today from the woman you were 20 years ago?

How are you the same today as the woman you were 20 years ago?

What does your Thanksgiving table look like?

Who is seated around it?

What are you serving?

What is the conversation like?

Share a favorite Thanksgiving recipe.

A mother's love
will always be
needed.

JENNI BRENNAN

What does Christmas look like for your family now?

How do you decorate?

When and where do you gather?

What church service do you attend? What is it like?

Share a favorite Christmas recipe.

How does your family celebrate Easter now?

What do you wear?

Describe the Easter Sunday service you attend.

How do you make the day special?

Share a favorite Easter recipe.

What do you do every summer?

Describe any summer holiday celebrations.

Are there any places you visit as a family every year?

Are there any summer traditions you keep?

Share a favorite summer recipe.

What health challenges have you faced?

Share your most useful health tip.

When you think about your spouse, what do you feel?

When you think about your children, what do you feel?

What are your faith goals?

In what areas do you struggle most in your faith?

In what areas are you most confident in your faith?

What faith legacy do you hope to leave?

How has your knowledge of God changed over the years?

Are there any traditions you hope to start for your family?

What word or phrase best describes your life and why?

The title of a book about your life would be:

What do you pray makes
you unforgettable?

Your story doesn't end here.

These next pages are for you to write your
own message for the person holding this book.

**Your legacy of love lives on
in the words you share.**

IT'S NEVER TOO LATE TO TELL YOUR STORY.
KIM HOWARD

About the Author

LESLIE MEANS is founder and owner of the popular website *Her View From Home*, which features heartfelt contributor stories on motherhood, marriage, faith, and grief. She is the author of the bestselling book *So God Made a Mother*, is a former news anchor, and has published several short stories and two children's books. Leslie is married to a very patient man named Kyle, and together they have three fantastic kids: Ella, Grace, and Keithan. When she's not sharing too much personal information online or in the newspaper, you'll find her somewhere in Nebraska spending time with family and friends.

HE NEEDED SOMEONE WITH A HEART TENDER
ENOUGH TO ROCK BABIES IN THE STILL, SMALL HOURS
OF THE NIGHT BUT STRONG ENOUGH TO LET THEM
SPREAD THEIR WINGS AND FLY...

SO GOD MADE A MOTHER.®

No two mothers are alike. No two experiences in motherhood
mirror each other. But something powerful happens when our stories
come together: they speak love, worth, value, and beauty. They take
the undefinable experience of motherhood and give it shape and
substance and strength. They speak to us all.

So God Made a Mother promises to show you the
incomparable heart of a mother... a mother just like you.

Stories from the Heart
of Every Home

Connect with more stories of motherhood,

marriage, relationships, faith, and grief at

HERVIEWFROMHOME.COM

Follow along

@HerViewFromHome